Great Scott!

Entrepreneurship as I Know It

R'Kiyah Scott

Great Scott! Entrepreneurship as I Know It
Copyright © 2021 by R'Kiyah Scott

ISBN (978-1-63848-916-0)

Table of Contents

Foreword

Don't Just Look Great, Be Great!

I have never thought of myself as the "greatest." I simply believe that I possess the ability to be "great," and therefore, I do what is necessary to better cultivate my skills. So my purpose is revealed within the exhibition of my talent. As an entrepreneur who desires to be great, some things are non-negotiable. The non-negotiables of entrepreneurship are highlighted within "Great Scott! Entrepreneurship as I Know It," by Ms. R'Kiyah Scott. Based on the time we worked together during her photoshoot with Head Shot Studios and the content of her book, the non-negotiables are consistency, collaboration, and evolving competency! Please understand as a creative thinker, what I share with you is what I gleaned from Ms. Scott's surprisingly insightful knowledge and her delightfully humble yet joyously infectious presence.

Entrepreneurship is either constructive or catastrophic. When entrepreneurship is approached or regarded as a "one man/woman show" it will be catastrophic because the return on the individual's investment will not render residual earnings [customers] or profit [monetary compensation beyond overhead cost]. However, when entrepreneurship is strategically ventured the return on the individual's investment will be mutually constructive. Therefore, it will render residual earnings [new customers & return customers]. These individuals will help grow and sustain your business.

Consistency, within entrepreneurship is vital! Contrary to popular belief, entrepreneurs cannot do whatever they want. Though entrepreneurship provides more control and flexibility with our time, if we are in business, people will expect us to be business minded. Which means, entrepreneurs must have and maintain consistent "open" hours, superior

customer service, services, and products. Simple things like answering customers inquiries (via website, email, or phone calls), punctuality, and ensuring quality products and services will not only sustain entrepreneurs but it will establish a reputation that works for them and not against them.

Additionally, collaboration with customers and professional colleagues allow entrepreneurs to enhance their brands as well as their business practices and perspectives. Collaboration nullifies competition while promoting balance, harmony, and positive outcomes.

I have been a professional photographer for 43 years and I secured my first professional photoshoot when I was 15-years-old (it was a wedding). Within my tenure as the Chief Photographer of Head Shot Studios, I have photographed Mikhail Gorbachev, former President of the Soviet Union; Presidents Bill

Clinton and George W. Bush; then Senator Barack Obama, Actors Bill Murray, Vivica Fox, Morris Chestnut, and John Travolta (this is not a conclusive list). Whether I am collaborating with a hometown neighbor or a recognizable celebrity, I have learned to always maximize my influence on the client's experience.

Finally, entrepreneurs must be competent in their business practices and skills as well as their knowledge of business. Their skillset must continually evolve to meet the needs of their clientele. This means all entrepreneurs, no matter what they do must be willing to be lifetime learners. By refusing to educate yourself to enhance your skills, you to be left behind. Those who are successful entrepreneurs must be exceptional at everything within business and not simply be talented. Therefore, being good is never enough. Successful entrepreneurs know it is vital to always strive for excellence; thereby making it the norm.

Aspiring, novice, and veteran entrepreneurs must be consistent, collaborative, and competent. Think of entrepreneurship as an art, which increases in value over time.

From one entrepreneur to another, your vision is worth building. So, build it well!

Great Scott! Ms. R'Kiyah provides excellent advice!

Introduction:

WNBA... Un*Certainly*

Although, growing up I had several aspirations, I was certain that one day I'd play for a professional basketball league or own my own business, of some sort.

As destiny would have it, I received a full-ride scholarship to the College of Central Florida. I graduated with my Associate's degree and then transferred to Florida Agricultural & Mechanical University (FAMU). I majored in physical therapy and I totally despised it. I was insanely bored, and the math and science got the best of me!

Well actually, it brought out the worst in me. I asked myself, "Why are you putting yourself through this torture?" The major that I majored in could make me money, but I *couldn't* dropout; my parents would definitely look at me funny [in my

sane Kanye voice] but I ascribed to be a college dropout, *anyway*.

Within my first year at FAMU, I lost almost every ounce of motivation I had. I was homesick, lonely, and I didn't have any friends "on the hill." I lived a sheltered life before arriving at college. Ironically, instead of finding myself, I lost myself.

I had sunk into a dismal depression as I routinely went through the motions of going to class and returning to my apartment. Failure... this is what I believed

I'd become, and I wondered if I'd ever bounce back. I could not grasp my hope... [or, so I thought].

Then one day, I started "playing" around with my camera [again, I'd always liked taking pictures]. My cousin came to visit me unexpectantly. We decided to go to the beach, and

I grabbed my baby "Kapture" [my camera] to come along for the ride.

As the sunset, I captured amazing maternity photographs of my cousin. The photos were breathtaking. My hope returned and my entrepreneurial spirit was awakened... Great Scott!

Now that I am almost the big 3-0, I am a thriving entrepreneur, and I want to share my knowledge with you; it will empower anyone, specifically millennials [who aspire to be entrepreneurs]. I hope that every reader is inspired in multiple ways and that your spirit is triggered with relentless zeal.

By the end of this book, I am confident you will glean invaluable nuggets, strength, enCOURAGEment, be fearless, and develop the positive mentality of a *true* entrepreneur.

Chapter 1

Change Your Lens, Change Your Perspective

As a little girl I was quiet and bashful. I observed things more than I spoke about them because when I opened my mouth, it was because I really had something to say. When I started playing sports, I realized how important communication was. Ironically, my shy personality seemed nonexistent. I became quite popular as a shooting guard in both high school and college. My childhood dream was to one day play women's basketball at the professional level. I had learned and developed my basketball skills starting in third grade. I was trained by some of the best coaches and mentors Ocala had to offer.

My athletic achievements were countless in high school and at the collegiate level. I set school records that *still* haven't been broken. In high

school I was selected as player of the year (2012). Additionally, during my freshman year of college, I was named third team all-conference and first team all-conference my sophomore year. After two years of playing JUCO basketball, I transferred to FAMU.

When I arrived at FAMU, I no longer desired to play basketball. So, I focused on obtaining my degree in physical therapy. Fortunately, my time at FAMU was short lived and I did not earn my degree. I didn't need a degree in physical therapy to reach my destiny.

After I became a college dropout, I worked at a local beauty supply store to make ends meet. I was employed there for about two years before gaining enough experience to land a job as a receptionist at an ophthalmology practice. After a few months, I was promoted to a medical billing specialist, I still hold this position today; however, my aspirations have not allowed me to stop here.

In 2017, I stepped into the unfamiliar territory of entrepreneurship. My love for photography had to be more than a hobby or a hustle. Initially, I only photographed my family and closest friends. As my photography skills improved, I was given the opportunity to capture pictures for my church. I grew as a photographer and a believer. I am eternally grateful for this experience. Currently, I still serve as the ministry's photographer.

Due to the monotony of my photos, my creativity was staggered [there are only so many photos you can take within the sanctuary]. Lovingly, my church family encouraged and pushed me beyond my moments of self-doubt. As I reflected, on being an entrepreneur [not just a photographer], I realized when I changed my perspective, I also had to change my position.

My passion for capturing the intimacy of worship, challenged me to dig deeper into my

creativity. During worship, I assessed the sanctuary because I discerned the need to change my position and seize the authenticity of the worship experience. I needed my photos to establish a connection with every person that saw them; God had to be felt within *my* photography.

Entrepreneurs are individuals who accept change and understand the necessity of it. We know our perspective regarding life, finances, aspirations, and careers [or whatever you desire to achieve], must align with our individual purpose! This requires humility, courage, and the ability to refocus. In other words, change your lens and zoom in.

In order to change your perspective, you must change your position.

Great Scott! That's good advice.

Chapter 2

Relationships... Zoom In

Throughout our journey, we will come in contact with several individuals. As young entrepreneurs, we should form meaningful relationships and surround ourselves with people who are integral, motivated, and mature [equipped to handle success]; this is vital.

There are three types of relationships that will be elaborated upon: professional, family, and friendships. These three relationships are essential to our entrepreneurial careers and impact our journey on every level.

Typically, when we think of networking, we automatically think of it as a connection for exchanging business information or to enhance our product or services [improve visibility] and improve our bottom lines.

This is presumptuous, self-serving, and misleading. Our relationships must be mutually beneficial, and the exchange of information and ideas must reflect this through genuine reciprocity. So, it's not about what we can "get" but what we can "gain" together.

This belief starts with respecting ourselves as aspiring or budding entrepreneurs, which is why we cannot hustle. Hustling is selfish because it keeps individuals in survival mode; however, real entrepreneurship allows us to evolve into successful business owners [and take others with us]. Entrepreneurship is an opportunity to build. This is where we start to zoom in.

Networking should always present the opportunity to improve our skill sets while collaborating to help others achieve the same. When I initially started my photography business, I was hired to photograph an event for a fellow

female entrepreneur who was dedicated to helping novice entrepreneurs.

Although I was hired to work, I learned more than I thought was possible. I listened to the experiences of other entrepreneurs. Their stories of entrepreneurship not only inspired me, but immediately challenged me to level up!

After taking photos at the event, she hired me for a personal photo session. From that moment on, she expressed how she loved my work. Our professional relationship was established here, and we have collaborated on several projects until this day. She never saw me as a threat but recognized that she could only be better by helping me to be better. This is a prime example of an integral entrepreneur.

Although I never spoke to Trecia about how much she has inspired and influenced me, she has been one of the most influential people I've connected with on my entrepreneurial journey.

Networking and fostering genuine relationships help us to be great people and even better entrepreneurs.

During my evolution, my ignorance wasn't a hindrance, but it afforded me opportunities to connect with more knowledgeable entrepreneurs. They didn't know it all, in fact we can't know it all... there must be space to grow, learn and develop.

Often, I had no clue where to turn, I stumbled, researched, tried again, and researched some more. Finally, I reached out to someone who had a more expansive understanding of the pitfalls and pinnacles of business.

For the life of me I couldn't establish the price of my work to reflect the value of my work. It was like banging my head against a brick wall. Do I charge by the hour? Should I require a non-refundable deposit? Should I charge for travel, what about process time, how many photos should

the client receive? How long should a free consultation be?

Listen, I love my family and friends... God knows I do, but I'm not lugging my 30-pound camera [Kapture] and her lenses to photograph anyone for FREE!

When I connected with more businessmen and women who were established, who had access to more resources, perceptively I understood that entrepreneurship does not possess a one size fits all approach! However, the foundation is unchanging. It embodies respect, gratitude, reciprocity, and a hunger for growth and collaboration.

It is imperative to zoom in even tighter when maintaining friendships. This plays a huge role in the entrepreneur's life, particularly the success of our future. I have learned "friends" can make or break our careers. We must learn to discern the company we keep. Just because our

friends are with us now, this doesn't guarantee they will remain with us for the toast at the top.

Trust me, everyone does not have the same values, motivation, mindset, or work ethic. People change [I am people]. I have chosen not to surround myself with individuals who drain me mentally, physically, emotionally, and sometimes spiritually. Our friends should genuinely support us and desire to see us win. Either be a part of the hype crew or a whispering hater... it's impossible to do both.

Let's face it, solid friendships are crucial because friends help us deal with the ups and downs of entrepreneurship. Our friends usually play the role of what I like to call our free, unlicensed therapists. They help us alleviate stress, ease decision-making, and hold our hands through the toughest times in our lives. Sometimes we are able to glean and relate to friends more than anyone else. These friends eventually *become* family.

Family support in a young entrepreneur's life is extremely important as well... because it is the most influential. Our family usually provides the guidance, and inspiration we need. Family allows us to be who we are [without judgement]. When we're surrounded by family, we know these are people who love and care about our well-being.

Our primary support system is family, and we rely on our support systems for advice, support [emotionally, mentally, and financially]. Family invests in us in several ways. Our parents, siblings, cousins, and grandparents [or whomever we consider family] are not ATMs. Their personal investments include an outpouring of knowledge and wisdom that helps us reach our goals and manifest our dreams.

The most significant investment my family has given me is their belief that I am definitely the Great Scott! I am motivated by them to be better

and to surpass the expectations and goals that I've set for myself.

Additionally, when it comes to our family, we have the honor of adding to our legacy by becoming the first entrepreneur or making sure we aren't the last entrepreneur. It is our responsibility to serve as role models to our younger family members and inspire them to pursue their dreams. To this end, I am thankful that I embody the dreams and hopes of my ancestors.

Relationships should be mutually beneficial and cultivated upon self-respect and respect of others. These relationships should align with our purpose and core values [they'll never cause us to compromise or sabotage who we are]. Ultimately, the most purposeful relationships propel us into our destiny...so zoom in tight and make sure the connection is right!

Great Scott! That's good advice.

Chapter 3

Canon vs. Nikon... Don't Compare!

Comparing ourselves to other business owners is like comparing a Nikon to a Canon. Just DON'T do it! Although there are similarities, both cameras have different features/functions. As individuals, we share common ideas and talents; however, our purpose is different. Embracing our individual purpose allows us to function in unique ways. We should never compare ourselves to others because this causes self-doubt and unrealistic expectations.

Oftentimes, we beat ourselves up because we believe we should have achieved the same level of success as our peers. This is not a wise thing to do... Instead, we should focus on our progress and not the snapshots that have been presented to us of another entrepreneur's success. The pictures of their success are the filtered shots that have

been visually enhanced [before they shared their "success" with the world].

Truth is the most impactful development occurs in the darkroom. Metaphorically, the darkroom has plenty of dissatisfied customers, uncontrollable technical difficulties, devalued services, and several thoughts of quitting. However, those who have a relentless passion for entrepreneurship never give up, they keep striving to be better!

Improving our entrepreneurial mindset requires us to know what works best for us. For instance, the Nikon has a certain feel and frankly, some photographers prefer it over a Canon. Regardless of a photographer's camera, the editing process is essential. Don't get me wrong, a steady hand and a keen eye for detail are equally necessary. However, their skills must be coupled with an undying commitment to studying/stewarding their craft. Furthermore, the

more we practice, the better we become [this applies to anything we aspire to accomplish].

Now I have a confession to make, I'm a Canon girl! It's not because I think Canons are better but because it was the first camera my dad presented to me as a gift. So, my loyalty to the Canon band is sentimental, nothing more, nothing less.

We must learn to go at our own speed and trust that we are still making progress. Comparison is liar and a thief. It robs us of your joy, confidence, and motivation. If we allow it to, a comparison mentality will defeat us. Unfortunately, in many cases, comparison has caused rising entrepreneurs to walk away too soon.

Let's talk about admiration versus envy. Please understand, admiring or complimenting another person's work takes nothing away from us. Admiration should lead to inspiration; therefore, it should not lead to being envious or feeling

threatened by another individual's talents or accomplishments. To be envious is ludicrous because typically we only witness a person's journey through photos [or selfies] and not the processes behind the scenes.

We must choose the mentality that will lead us. Either we progress from admiration to inspiration to manifestation *or* we will become envious, jealous, and bitterly competitive. This leads to sabotage and sabotaging others. Unfortunately, the competition that has been created yields absolute nothingness [and is complete waste of time, needless frustration, and stagnation].

Whenever we admire someone, our goal should be to learn from them [not be them]. So be a student who follows their journey and is willing to learn from their experiences. We should apply these lessons to our best practices as we strive to be nothing less than exceptional

entrepreneurs. Business owners should crave continual improvement and focus on the bigger picture, which is our own individual success.

Optimism and motivation are difficult practices to maintain. Social media and society tell us that we should reach certain pinnacles, at specific times in our lives and these factors supposedly determine how successful we are. Please, don't believe the hype, and stop listening to this malarkey! Attempting to navigate our lives according to someone else's beliefs starts the elusive chase of success; don't try to "keep up with" others.

Your only competition is you [so run circles around yourself, daily]. Additionally, when we chase success it leads to the counterproductive practice of comparison. When we compare, we waste our time and our energy. Sadly, we discredit our creativity, and inhibit our ability to focus on

our growth in all capacities [this is really important].

Entrepreneurship isn't easy. Who wakes up and decides to hire and fire themselves? Those of us who are about this entrepreneurship life do it quite frequently. We accept the challenges, learn the lessons, and embrace the wins. So, understand this, entrepreneurs don't fail because when we try our attempts lead to greater opportunities. So, let's redefine "FAILURE:"

F is for faith. We must have faith and believe in ourselves as well as our brand [we are the billboards of our companies]. **A** is for ambition. Be diligent in achieving the goal(s). **I** is for improvement and investing [both are necessary practices of successful entrepreneurs]. **L** is for lucrative. Ensure that every practice in business yields a beneficial return [including a profit margin]. **U** is for unique. Establish your brand identity; it will set you apart. **R** stands for respect.

So, take your work seriously and others will too! Lastly the letter **E** is for excellence and efficiency. Never give less than your best and maximize every opportunity to become better. This is failure _redefined_.

Entrepreneurs must avoid the comparison trap,

and compliment others while also acknowledging

our work and celebrating personal growth.

Remember asking for help isn't a sign of weakness

but comparing ourselves to others is utter lameness.

Great Scott! That's good advice.

Chapter 4

Entrepreneurship... It's Risky Business

When we decide to take a risk, we become consumed by the idea of failure [relentlessly] until it paralyzes us from progressing. The "what ifs" trick our minds into believing the impossibilities rather than the possibilities, and consequently, we choose to do nothing.

Entrepreneurship requires us to be risk-takers; this is necessary for growth and progression. Taking chances is not easy, as a matter of fact, it is quite intimidating. However, we are entrepreneurs and taking calculated risks comes with the territory.

When I seriously considered my entrepreneurial journey, I had to invest in my business. I had been using an outdated HP laptop

that decreased my efficiency and productivity. I was at my wits end and I knew it was time to invest in an updated laptop, but I grappled with the necessity of the investment [it was $1,000 investment to be exact].

I had to decide to either process photos over a two-week period or have them ready in a couple of days. I experienced sticker shock (this is when the cost of what we need seemingly outweighs the value of it – this is usually a fearful misconception). I was afraid to invest such a large amount of money at one time.

My uncertainty was rooted in my frugality (my stinginess with money). After much consideration, I realized my self-motivation had to be stronger than my self-doubt. This investment would only help the growth of my business, it couldn't hurt me.

In this pivotal moment, I had an epiphany, and I understood that the biggest risk I would have

taken was not taking a risk at all! This experience taught me a valuable lesson, and it empowered me to push through my self-imposed limitations.

Taking risks are the essence of entrepreneurship!

Great Scott! That's good advice.

Chapter 5

Career, Hobby or Hustle... An Open Letter

Dear Fellow Entrepreneurs,

I have shared my experience and knowledge with you because I know what it is like when we attempt to build our empires and then realize we are alone. Our legacies require stamina, perseverance, and assistance. Entrepreneurship shouldn't be a lonely path, but a road of self-discovery while understanding the journey and those we encounter while we're on it.

My story is an open book of "entrepreneurship as I know it." If you don't remember anything else you've read, please adhere to the following **Great Scott Rules:**

Failure: Recognize that failure is a part of the journey and it's placed on our paths to help

us bloom. When we fail, we also learn because if we don't learn, we will not grow.

Customer Service: The paramount of business is superb customer service. Our clients are advertising agents, so roll out the red carpet.

Don't Undervalue: Entrepreneurs must know our worth. We are qualified! We can't sell ourselves short or settle. We oversee businesses, not auctions [we set our prices, this is non-negotiable].

Guiding Principles: The most significant principles of entrepreneurship are brand confidence, self-care, industry knowledge, business improvement, and diligence.

Establishing Legacy: As entrepreneurs we should desire to be remembered for our

accomplishments and how our passion became our purpose. This is legacy!

Great Scott! This WHOLE book is good advice,

on entrepreneurship as I know it!

About the Author

R'Kiyah Scott is a Florida native, and she currently lives in the state's capital city, Tallahassee. As the "Great Scott," she has captured countless memories for her clientele [near & far], thus providing beautiful points of reference for the most significant and unforgettable moments of their lives.

As an entrepreneur within the world of photography, R'Kiyah has strategically studied her craft, and cultivated her personal and professional relationships purposely. Her clients absolutely adore intuitiveness within their photoshoots. Ms. Scott keenly captures every emotion that her clients convey beautifully during "Kiy's Photography" sessions!

In her spare time. R'Kiyah enjoys spending time with her family and close friends, traveling, studying various forms of photography, and pampering herself with much needed self-care.

Notes

Notes

Notes

Notes

Notes

CPSIA information can be obtained
at www.ICGtesting.com
Printed in the USA
LVHW090129050521
686548LV00007B/543